THE NEW NORMAL

THE NEW NORMAL

Sophie Calle

Mohamed Camara

Hasan Elahi

Eyebeam R&D/Jonah Peretti and Michael Frumin

Kota Ezawa

Miranda July and Harrell Fletcher

Guthrie Lonergan

Jill Magid

Jennifer and Kevin McCoy

Trevor Paglen

Corinna Schnitt

Thomson & Craighead

Sharif Waked

Michael Connor
with essays by Marisa Olson and Clay Shirky

Independent Curators International, New York
Artists Space, New York

Published to accompany the traveling exhibition *The New Normal*, organized by iCI (Independent Curators International), New York, and Artists Space, New York, and circulated by iCI

Exhibition curated by Michael Connor

Exhibition Funders
The exhibition, tour, and catalogue are made possible, in part, with funding to iCI from The Horace W. Goldsmith Foundation, the iCI independents, The Cowles Charitable Trust, The Overbrook Foundation; iCI members Gerrit and Sydie Lansing, Barbara and John Robinson, Jill Brienza and Nicholas L. Daraviras, Jean Minskoff Grant and T Grant, Ann and Mel Schaffer, Liz and Marv Seline, and Barbara Toll; and in-kind support from We Have Photoshop; and to Artists Space from the Andy Warhol Foundation for the Visual Arts, the Starry Night Fund of the Tides Foundation, The Cowles Charitable Trust, the British Council, the New York City Department of Cultural Affairs, and with public funds from the New York State Council on the Arts, a State Agency; and for the catalogue from the David S. Howe Foundation, the John S. Johnson and Susan R. Short Foundation, Alexander and Bonin, Carla Emil and Rich Silverstein, Dorothy Lichtenstein, and Luhring Augustine.

iCI (Independent Curators International)
799 Broadway, Suite 205, New York, NY 10003
Tel: 212.254.8200 Fax: 212.477.4781
www.ici-exhibitions.org

Artists Space
38 Greene Street, 3rd Floor, New York, NY 10013
Tel: 212.226.3970 Fax: 212.966.1434
www.artistsspace.org

Library of Congress: 2008921937
ISBN: 978-0-916365-79-0
Editor: Stephen Robert Frankel
Designer: Christine N. Moog
Publication Coordinator: Frances Wu
Printer: Transcontinental Litho Acme, Canada

Cover: Kota Ezawa, *Home Video II*, 2007 (detail of image on p. 47); page 2: Hasan Elahi, *Tracking Transience: Interstate*, 2007 (detail of image on p. 35); page 6: Thomson & Craighead, *Beacon*, 2007 (detail of image on p. 42)

Lenders

Bellwether Gallery, New York
Galerie Pierre Brullé, Paris
Hasan Elahi
Electronic Arts Intermix (EAI), New York
Kota Ezawa
Harrell Fletcher
Murray Guy, New York
Miranda July
Yvon Lambert Gallery, New York
Guthrie Lonergan
Jennifer and Kevin McCoy
Trevor Paglen
Postmasters Gallery, New York
Corinna Schnitt
Gallery Olaf Stueber, Berlin
Thomson & Craighead
Sharif Waked

Exhibition Itinerary*
Artists Space
New York, New York
April 25–June 21, 2008

Huarte Centro de Arte Contemporáneo
Huarte, Spain
July 4–September 28, 2008

Decker Gallery, Maryland Institute College of Art
Baltimore, Maryland
November 6–December 14, 2008

Canzani Center Gallery, Columbus College of Art & Design
Columbus, Ohio
February 11–April 22, 2009

Pomona College Museum of Art
Claremont, California
August 25–October 19, 2009

* at time of publication

LAND PROPERTY AT CENTER HILL LAKE

29 June – 31 July

gate centre →

Contents

Foreword and Acknowledgments

In just the past few years, our expectations for privacy have changed radically. With surprisingly few signs of public protest, we have accepted a sizable, involuntary loss of privacy since 9/11 due to increased national security. We live now with heightened surveillance and numerous other methods for collecting our personal information: this is "the new normal" described by United States Vice President Dick Cheney in 2001.

Simultaneously, the norms for what we regard as the private sphere and for giving up privacy voluntarily have changed perhaps even more radically. The ever-expanding presence of the Internet and online social networks, often referred to as "Web 2.0," have propelled millions of people around the world to willingly share personal information without any means of controlling who receives it or how it will be used. Furthermore, it has become commonplace to have all our purchases and Internet activities tracked, and our real and virtual friendships intertwined.

When Michael Connor proposed to us his concept for an exhibition called *The New Normal*, we recognized its timeliness. We immediately understood the vital impact the works in such a show could have on visitors to the exhibition — their potential to provoke fresh insights, raise difficult questions, and examine the ambiguities of the issues involved in the voluntary and involuntary loss of privacy.

In *The New Normal*, these complex issues are explored in recent works of art and research projects by thirteen artists and cultural researchers on several continents. These video pieces, computer installations, and works on paper reflect the current political, social, and cultural debates over protecting or relinquishing personal information. They investigate a wide variety of situations involving the absence of privacy, with implications that range from the personally destructive to the creatively productive.

This catalogue and traveling exhibition have been made possible with the encouragement and dedication of a great many people. First and foremost, we extend our warmest thanks to Michael Connor for curating this compelling and timely exhibition with an

approach that is insightful, imaginative, and highly informed. His essay published here enables a wider public to "experience" the works and ideas explored. Grateful acknowledgment is also due to Michael's co-authors in this catalogue—Clay Shirky, writer and adjunct professor at New York University's graduate Interactive Telecommunications Program; and Marisa Olson, artist, critic, and curator. They have contributed thought-provoking essays with distinctive and original voices, elucidating the ideas presented by the artists in the exhibition and how they relate to our lives.

The curator joins us in expressing our gratitude to all the artists whose work we are proud to present in this exhibition, and to voice our special appreciation to Jennifer and Kevin McCoy, Hasan Elahi, and Jill Magid. We are also indebted to the lenders, who have generously allowed their works to travel during the two-year tour, and to many others who have assisted throughout the curatorial process. In particular, the curator would like to thank the following who helped with research for the exhibition: Lauren Cornell, director, Rhizome, New York;

Paul Domela, program director, Liverpool Biennial; Josh Kline, director, Communications and Public Programs, EAI, New York; Chus Martinez, director, Frankfurter Kunstverein; and David Nolen. His thanks also go to those who helped locate artists and works of art, and assisted in other respects: Pierre Brullé, Galerie Pierre Brullé, Paris; Sophie Djian, exhibitions coordinator, BFI, London; Galit Eilat, director, Digital ArtLab, Holon, Israel; Kristina Ernst, gallery manager, Bellwether Gallery, New York; Janice Guy, director, Murray Guy, New York; Vincent Honoré; Yvon Lambert, Yvon Lambert Gallery, Paris/New York; Yuri Ono, designer, Learning to Love You More; Sara Smith, exhibitions manager, FACT, Liverpool; and John Thomson, director of distribution, EAI, New York. We would also like to thank Octavio Zaya for his enthusiastic support of this project, and for arranging for *The New Normal* to travel to Huarte Centro de Arte Contemporáneo, Huarte, Navarra, Spain.

On behalf of the Board of Trustees of iCI and Artists Space, we would like to express our sincerest thanks to the generous sponsors of

The New Normal who share our vision for this project and who have made generous contributions to help make it possible. iCI is indebted to the Horace W. Goldsmith Foundation and the iCI independents, for their support of this project, and We Have Photoshop for their in-kind support. Artists Space would like to express its special thanks to the Andy Warhol Foundation for the Visual Arts, the Starry Night Fund of the Tides Foundation, and the British Council, as well as to its supporters for this publication, the John S. Johnson and Susan R. Short Foundation and the David S. Howe Foundation.

Sincere appreciation is due to Christine Moog, for her graphic design of this catalogue; to Stephen Robert Frankel, who edited the texts, and to Sebastian Campos, Mike Gallagher, Rebecca Gimenez, and Andrew Shurtz of We Have Photoshop for their design of the Web site accompanying the exhibition. It was a great pleasure to work with these superb professionals.

We express our appreciation to the dedicated and energetic staffs of our institutions that have contributed their professional skills, creativity, and enthusiasm to the production of this publication and exhibition. At iCI, thanks go especially to Susan Hapgood, director of exhibitions; Frances Wu, curatorial associate; Rachel May, registrar; and Teresa Iannotta, exhibitions intern. At Artists Space, we would like to thank Amy Owen, director of exhibitions; Hillary Wiedemann, gallery manager; and Mirelle Borra, Web master.

Finally, we extend warmest appreciation to our boards of trustees for their continuing support and commitment. They join us in expressing our gratitude to everyone who has helped in the realization of this exhibition, catalogue, and tour.

Judith Olch Richards
Executive Director, iCI

Benjamin Weil
Executive Director, Artists Space

The New Normal

MICHAEL CONNOR

SEPTEMBER 27, 2001—SEATTLE, WASHINGTON, U.S. Amazon.com announces a new initiative called Your Store, which automatically sets up a fully personalized page for each returning customer, including name and past purchases.[1]

OCTOBER 12, 2001—KARLSRUHE, GERMANY. An exhibition called *Ctrl [Space]: Rhetorics of Surveillance* opens to the public. The exhibition brings together a range of works from the 1960s to the present day that reflect and critique the omnipresence of surveillance, and the increasing automation of data-gathering.

OCTOBER 25, 2001—WASHINGTON, D.C. Dick Cheney gives a speech to the Republican Governors Association about the U.S. government's response to the September 11 attacks. He states, "Many of the steps we have now been forced to take will become permanent in American life. They represent an understanding of the world as it is, and dangers we must guard against perhaps for decades to come. I think of it as the new normalcy."[2]

OCTOBER 26, 2001—WASHINGTON, D.C. George Walker Bush signs into law the U.S.A. Patriot Act. Among the hundreds of new security measures in the bill are many that greatly expand the power of U.S. law-enforcement officials and intelligence agencies to gather electronic data about suspected terrorists and all subscribers of any monitored Internet service provider.

APRIL 25, 2008—NEW YORK, NEW YORK. A touring exhibition called *The New Normal* opens to the public.

The concept of privacy is widely invoked, but difficult to define. Something is private when we have some level of control over who has access to it, whether it is our domestic space, body, thoughts, communications, or behaviors. These contexts are

rendered inaccessible to the public eye (and ear) by legal, social, and physical boundaries, such as wearing clothing that covers most of the body, or not listening to a nearby cell-phone conversation. These practices are so much a part of the fabric of everyday life, they only become visible when they change.

Changes affecting the private sphere are often linked to the introduction of new technologies. There is no mention of privacy in the United States Constitution, nor in other U.S. law prior to the invention and manufacture of the Kodak handheld camera in 1888.[3] In one of the first discussions of privacy law in the U.S., Samuel Warren and his law partner Louis Brandeis wrote that "numerous mechanical devices threaten to make good the prediction that 'what is whispered in the closet shall be proclaimed from the house-tops.'"[4] The year was 1890.

In the past several years, we have seen a similarly profound shift in the nature of privacy. New tactics for gathering and analyzing data have given governments and businesses fresh insights into the behavior of consumers, suspected criminals, and others. Debates about surveillance, once centered on the presence of cameras in shopping malls and on city streets, have become increasingly focused on online behavior and communications.

Yet the rise of state and corporate surveillance has not been the only, or perhaps even the most definitive, factor affecting the private sphere since 2001. Equally remarkable has been the willingness demonstrated by millions of us to document and reveal our own behavior and the behavior of others, in personal photos and video clips posted on blogs and online diaries, or just sent via e-mail. The most shocking criminal evidence in this young century was not captured by surveillance cameras, but by the camera phones of soldiers at Abu Ghraib prison. And in the ordinary course of our daily lives, we readily disclose information about

ourselves to online vendors for the sake of convenience, and share personal matters as part of our online identities. Thanks to changing social attitudes, new technologies, and political fluctuations, aspects of our lives that were once private are now newly visible.

The New Normal is an exhibition of thirteen works of art completed after 2001 that draw on private information for their raw material and subject matter. Some deal with private spaces, and the ability to shield these spaces from unwanted intrusion. Others deal with data capture and data sharing — the acquisition, disclosure, and use of private information. Issues of compliance and power are also addressed in several of the works, raising the link between privacy and a sense of personal autonomy.[5]

We live in a time of confessions, both voluntary and forced. Yet what emerges most strongly from this exhibition is the idea that the revelation of private information is not always something to fear. Instead, we can form our own responses to these altered conditions that have changed the way we live. We can build intimacy and connect with others, experiment with our identity and persona, and develop tactics for political critique. Disclosure is a game with its own rules and aesthetic codes. It is these rules and codes that form the foundation of our investigation.

FOUND PORTRAITS

FEBRUARY 17, 2003 — MILAN, ITALY. Muslim cleric Osama Mustafa Hassan Nasr, also known as Abu Omar, is abducted as he walks to his mosque.

MARCH 2003 — ROME, ITALY. C.I.A. station chief Jeffrey Castelli sends a memo to Italian law enforcement officials falsely stating that Nasr "may have traveled to an unidentified country in the Balkan Region."[6]

TREVOR PAGLEN/
*SIX C.I.A. OFFICERS WANTED
IN CONNECTION WITH THE
ABDUCTION OF ABU OMAR
FROM MILAN, ITALY/*
2007/
(INSTALLATION VIEW)/
SIX INKJET PRINTS/
EACH, 14 5/8 X 14 5/8 IN.
(37.1 X 37.1 CM) FRAMED/

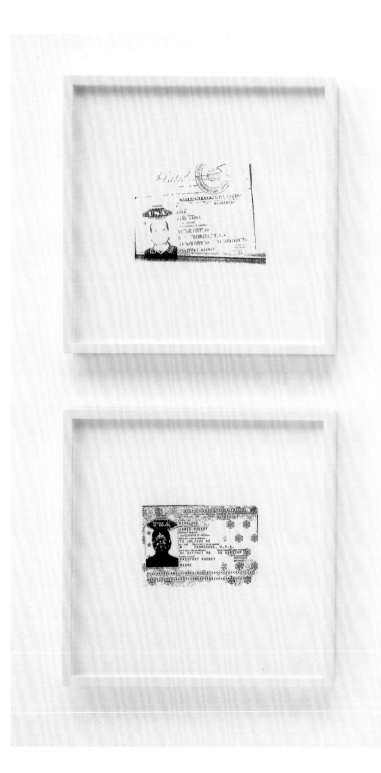

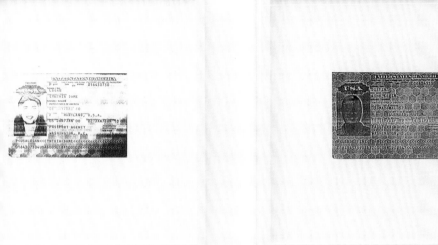

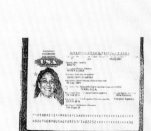

JUNE 22, 2005 — MILAN. Italian judge Chiara Nobili signs arrest warrants for thirteen C.I.A. agents connected with the disappearance.[7]

A grainy, black-and-white photocopy of a passport lists the name of its holder as Maria Luana Baetz, born September 25, 1969 in Texas. In the photo, she flashes a wide smile, but this may be the only authentic part of the document. The real name of the smiling woman is Monica Courtney Adler (actually born on February 2, 1973 in Seattle, Washington), and she is a C.I.A. agent wanted in Italy for kidnapping — part of the Bush administration's policy of abducting suspected terrorists and transporting them to countries where they can be subjected to torture in order to extract information and confessions.

Adler's image appears in one of the works in this exhibition, Trevor Paglen's *Six C.I.A. Officers Wanted in Connection with the Abduction of Abu Omar from Milan, Italy* (2007). It consists of six inkjet prints of documents released by Italian prosecutors in 2005: enlarged black-and-white photocopies of the passports used by the C.I.A. agents involved in the kidnapping of an Egyptian cleric from Italian soil. The work is displayed in the gallery as a series of portraits. Each portrait combines a fact with a fiction: a real image of the subject with a caption fictionalized by government operatives (passport number, name, date of birth—all fake). The factual image makes the hidden visible, granting us a glimpse of a face whose real identity is meant to remain unknown, a glimpse behind the veil of a government ruse. The official fictions printed on the passport are no less fascinating. The names listed are fictional characters. They carry so much authenticity, but they were made up in an office in the Pentagon. One wonders, did they belong to former sweethearts

of people who wrote these cover stories? Were they picked from a phone book?

The work *Six C.I.A. Officers* represents the revelation of a secret, a cover blown (but not, of course, by Paglen). Paglen traffics in military secrets. His projects bring much-needed transparency to a U.S. government that seems to believe that the means are always justified. The work reminds us that surveillance is not only a tool of the state, but can also be used by the public to bring accountability to officials who have done wrong.

AUGUST 26, 1983–MINNEAPOLIS, MINNESOTA, U.S. Pamela Magnuson withdraws money from a bank's A.T.M. Shortly afterward, two men appear and knock her senseless. The attack is captured on videotape.

1988–MINNEAPOLIS. An American bank invites French artist Sophie Calle to make a work for them. She accepts. The bank's private detective offers Calle seven images from the bank's security cameras, including images of the A.T.M. attack.

Sophie Calle has been variously described as a diarist, behavioral scientist, and detective. Surveillance and disclosure are recurring themes in her work, beginning with her early photograph/text installations, such as *La Suite vénitienne* (*Venetian Suite*, 1980; not in the current exhibition), for which Calle followed a man surreptitiously through Paris and Venice, documenting his movements through photographs and written reports. In 2007, at the Venice *Biennale*, she exhibited *Prenez soin de vous* (*Take Care of Yourself,* 2007; not in the current exhibition), a series of works based on an e-mail sent by a lover telling her he was breaking up with her, and the responses of 107 women to that e-mail.

RIGHT AND OPPOSITE:/
SOPHIE CALLE/
UNFINISHED/
2005/
(VIDEO STILLS)/
SINGLE-CHANNEL
VIDEO WITH SOUND/
30 MINS., 14 SECS./

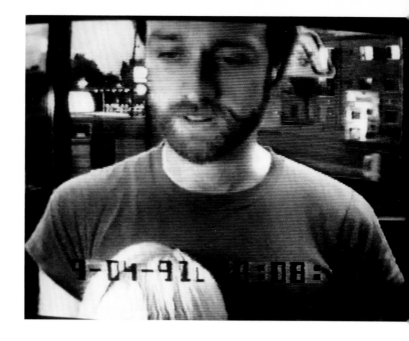

Capturing, revealing, and studying private information is a central tactic in many of her works.

Calle's video work *Unfinished* (2005) documents an artistic process that began in 1988 with the private detective's offer of security-camera images. Fascinated by them, she would go on to steal many additional surveillance images from the bank. Taking over Calle's usual role of evidence collector, the surveillance camera provided a series of portraits, each subject seemingly unaware of being filmed. Their faces registered tiredness, anxiety, and the other unfiltered expressions that people use when they are assured of being alone.

Calle's attempt to incorporate these found portraits into her work led her down a number of artistic dead ends. In 1991, she presented a series of the images as framed photographs under the title *Cash Machine*, but felt that the project was a betrayal of her own style. Calle later wrote, "I kept thinking that these images were not enough in themselves. They needed text. This text that is *me*. My trademark: *image and text*."[8] Without introducing anything new into these images, could she really expect them to convey her intent?

For fifteen years, Calle struggled to insert her own voice into the bank's images, trying different strategies, and subsequently discarding each one. She ultimately freed herself from this

artistic roadblock by making a video work that documents the trajectory of the piece's creation, which she titled *Unfinished* as an admission of artistic failure. In parallel with the surveillance camera, which had captured the private moments of strangers, Calle's camera revealed her own artistic process, showing all the false starts, self-doubts, and blind alleys that are normally hidden from audience view. The bank's disclosure is replaced by the artist's confession: the piece moves from the third person to the first person.

Like *Unfinished*, Guthrie Lonergan's *MySpace Intro Playlist* (2006) also uses found portraits as the source material. The piece is a collection of videos made by young people who are members of the popular Web site MySpace.com. MySpace members can create their own online profile pages, featuring any images, music, text, and/or video they choose to present, and can post lists of their friends and music interests there, and communicate with peers and strangers. For many young people, these pages have become an integral part of the image they project to

GUTHRIE LONERGAN/
MYSPACE INTRO PLAYLIST/
2006/
(VIDEO STILLS)/
TWO SINGLE-CHANNEL VIDEOS
WITH SOUND/
8 MINS.; 13 MINS./

the world. The videos in Lonergan's piece are a part of an evolving genre of creating a public persona. They are meant to be viewed as video clips embedded directly into each maker's MySpace page, and they reflect the social conventions of that space. They run about one minute in length; in many of the videos, the makers directly address you, the visitor to their page: "Don't leave without leaving a comment, or a picture comment"; "Hello, America"; "Thanks for stopping by." Some of the makers are relatively straightforward and sincere, while others turn the situation into a joke or a skit.

Unlike *Unfinished*, Lonergan's piece is based on the simple artistic gesture of selecting videos and re-presenting them in a new context. Seeing the videos outside their original context underscores their specific aesthetic and social conventions. Lonergan's accidental subjects offer a much more consciously

constructed version of themselves than Calle's. The people in the security-camera photos from *Unfinished* are captured off guard in solitary moments. Their faces register emotions, but these are not their "social faces"; they do not intend to convey these emotions to others. The makers of the *MySpace Intro Playlist* may also be solitary, but their videos are explicitly social, intended as a kind of conversation-starter for visitors to their page, a conversation that can continue by posting messages and comments on the site.

Lonergan's piece, making use of videos deliberately created for public view, feels like a greater invasion of privacy than Calle's, which reveals images never intended for public view. The image presented by each maker of a MySpace video may be a heavily filtered persona, appropriate to the public space of MySpace —but when such images are taken from their original context, they tend to be read very differently than the way their makers intended. Even though these videos exist in full public view on the Web, that doesn't mean that all of us are invited to look.

PRIVATE SPACES

1945—BAMAKO, MALI. Seydou Keita begins taking photographs with a 6x9 cm camera that one of his uncles brought back from Senegal. The only foreign photographs available to him for comparison are found in the Manufrance catalogue (a French equivalent of the Sears catalogue in the U.S.).[9]

1951—BAMAKO. Jean Rouch presents his seventh film, *La chasse à l'hippopotame* (*The Hunt of the Hippopotamus*), to an audience that has never before seen film. They ask two things: "Why don't we see more of the hippopotamus?" and "Why did you add music?" Rouche replies, "But you don't recognize this music? It's the music that gives courage to the hunters." Their reponse: "But you're an

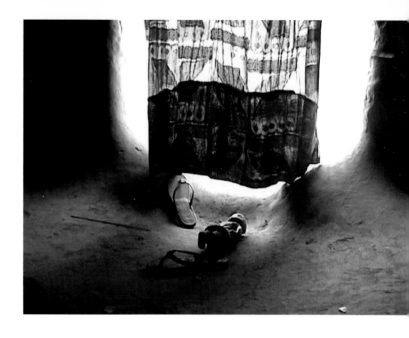

idiot! Where you put the music, the hippopotamus is underwater, and it's to him that the music gives courage."[10]

2001–BAMAKO. Eighteen-year-old Mohamed Camara receives a camera from French photographer Antonin Potoski.

Until Mohamed Camara was eighteen years old, his passion in life was football. As a teenager, he began taking photographs with a camera given to him by Antonin Potoski, a French photographer living in Bamako. Afraid that his new camera would be stolen if he used it in the streets, Camara began to take photographs exclusively within the private spaces where his friends and family resided.

In 2004, he made *Les Rideaux de Mohamed*, (*The Curtains of Mohamed*) a video work about the curtains that hang in the doorways of houses in Bamako. It is all shot from the relative safety of domestic interiors, looking out at a sun-drenched street through thin curtains that move back and forth in the breeze. The curtain is a fluid membrane, but despite its fragility, this boundary is enough to allow Camara to work without hindrance. The work has an air of intimacy, and yet it refrains from any direct portrayal of the inhabitants of the homes in which it is shot.

Another work in the exhibition also takes uninhabited private spaces as its subject: *Learning to Love You More* (2005), a series of photographs taken by visitors to a Web site founded by artists

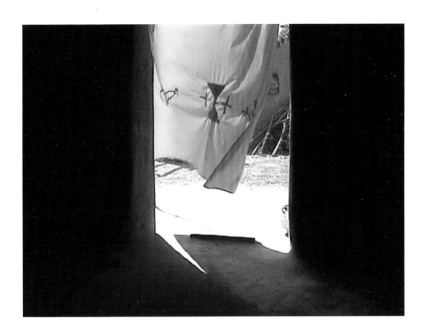

Miranda July and Harrell Fletcher. These photographs are the result of one of the art "assignments" that July and Fletcher regularly post on learningtoloveyoumore.com. Members of the public complete the assignments, and send the work that they create along with a report, which can take the form of a written text, photographs, or a video. All of these are presented on the Web site.

The assignments often look for inspiration to the mundane aspects of people's lives, unachieved goals, or revelations about flaws and frailties—for example, asking them to document their bald spot, hang wind chimes in a parking lot, describe their ideal government, or write about their scars. *Assignment #50* (shown in the current exhibition) invited participants to take a flash photograph of the space beneath their beds. The site asks:

> Don't vacuum or alter anything under your bed beforehand.
> Take a photo under there with a strong flash, preferably with
> the camera sitting on the ground. Make sure your photo-
> graph is in focus! We are looking for photos that depict the
> space between the bottom of the bed and the floor, please do
> not send us photos if your bed is flush against the floor.

At the time of this writing, 460 people who took on this assign-
ment had contributed photographs of something that usually
remains hidden from view.

MOHAMED CAMARA/
LES RIDEAUX DE MOHAMED
(*THE CURTAINS OF MOHAMED*)/
2004/
(VIDEO STILL)
SINGLE-CHANNEL VIDEO
WITHOUT SOUND/
65 MINS./

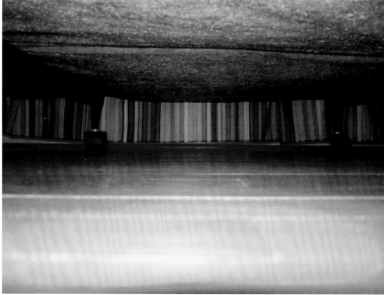

For most of us, the space under our bed is simply a repository of junk. For others, it might inspire fear: this is where monsters lurk. But it also taps into another motif that runs through the *Learning to Love You More* project—that is, the opportunity to reflect on past traumas, such as the aforementioned scars. The space under the bed is a hiding place for kids as well as for monsters, a place for youngsters to take refuge when they are in trouble with adults, or to avoid abusive situations.

This work by July and Fletcher thus points to a darker side to the idea of privacy, often raised in feminist writing about this issue: The sanctity of the private sphere can be a tool for abuse

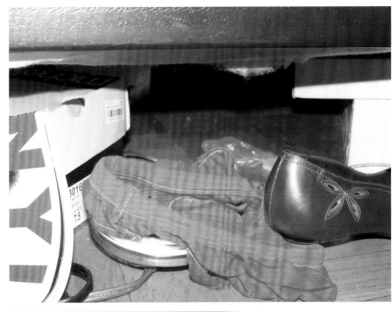

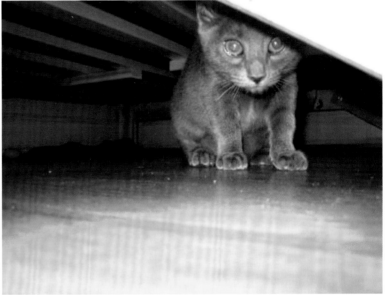

and repression, particularly of women. For example, a man who believes that his home is his castle may feel that he can be violent or abusive to his wife or children without fear of retribution. Feminist scholar Catharine MacKinnon describes the private domain as "the distinctive sphere of intimate violation and abuse, neither free nor particularly personal." [11] In cases of physical harm, events that take place behind closed doors must become the business of the state. Even in the home, privacy is not necessarily sacrosanct, nor should it be.

For Camara, the line between public and private space offers protection; for others, it may offer only oppression. The sanctity

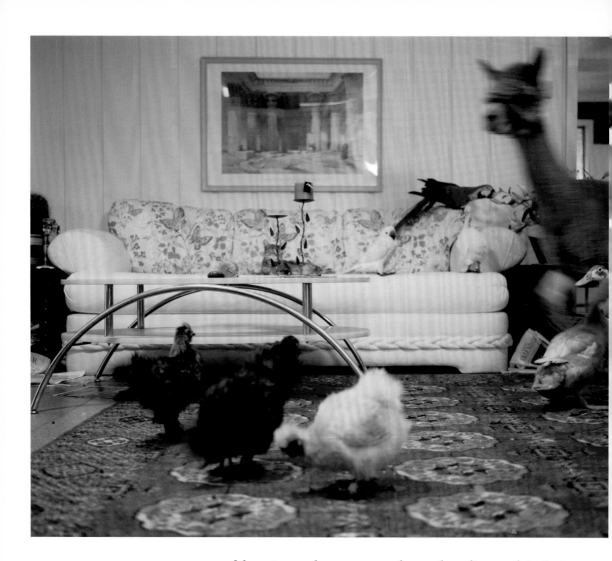

ABOVE AND OPPOSITE:/
CORINNA SCHNITT/
ONCE UPON A TIME/
2005/
(VIDEO STILLS)/
SINGLE-CHANNEL VIDEO
WITH SOUND/
25 MINS./

of the private sphere comes under an absurdist attack in Corinna Schnitt's video *Once Upon a Time* (2005). As in Camara's video and the photographs in *Learning to Love You More*, the site it shows is unpeopled domestic space. A camera pans the room slowly, taking in potted plants, books arranged neatly on shelves, a goldfish in a bowl. Suddenly two cats enter the room, followed by a succession of domestic animals, eventually comprising an entire menagerie. Soon, the disturbance of suburban bliss is in full swing: A goat eats the potted plant. A dog drinks water from the fish bowl. A llama appears and runs after some hens and ducks.

Schnitt's piece represents an invasion of private space, playing on the expectation of domestic tranquillity set up by our initial view of the conventional middle-class living room. The transformation of the space from house beautiful to farmyard is not just absurd, it is also somehow cathartic. Perhaps the

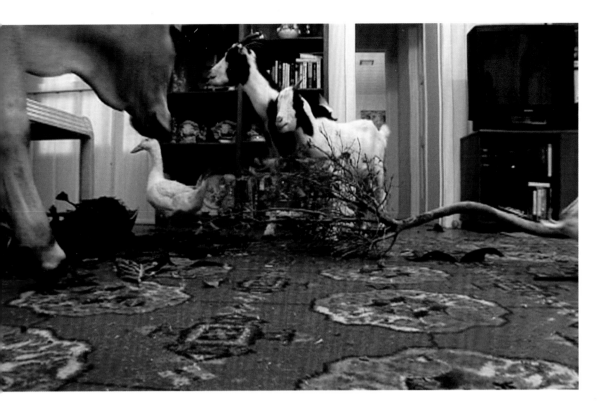

destruction of the private sphere isn't something to fear, but an opportunity to create something new, more fluid and liberating than what we had before.

COMPLIANCE

SEPTEMBER 12, 2001—TAMPA, FLORIDA, U.S. *Hasan Elahi, an assistant professor of art at the University of South Florida in Tampa, stops at U–Store It to pay rent on a storage unit. The manager alerts law enforcement officials of having seen a Middle Eastern man (Elahi was born in Bangladesh) carrying explosives and fleeing the area.*

JUNE 19, 2002—DETROIT, MICHIGAN, U.S. *Elahi arrives on a flight from Amsterdam, on his way back from a trip to Senegal, Mali, the Netherlands, and several other countries. He is stopped by immigration authorities and is led to an Immigration and Naturalization Service detention room for questioning by the F.B.I.*

During his first interrogation by the F.B.I. at Detroit Metro Airport in June 2002, Hasan Elahi was asked to reconstruct his movements in the days leading up to 9/11, and his P.D.A. got him off the hook: he used its calendar to show his exact whereabouts

HASAN ELAHI/
TRACKING TRANSIENCE: JSA/
2005/
CHROMOGENIC PRINT/
30 X 80 IN.(75 X 200 CM)/

at any given time. Nevertheless, he found himself the subject of a continuing investigation by the F.B.I., and was repeatedly called in for further questioning. After passing a lie-detector test nine times, Elahi was finally told he had been "cleared." He asked for a letter from the F.B.I. stating this in print, to prevent future mishaps with officials of U.S. Customs and Immigration Enforcement; but they refused, instead suggesting that Elahi should check in with the F.B.I. beforehand each time he travels.

So that's what he did — and more. Elahi began working on an elaborately constructed digital alibi: a Web site containing images of everywhere he goes and almost everything he does (always showing his current whereabouts). Elahi manually photographs his environs, transmits the mobile shots to a computer online via text messages that indicate his current address, and then adds an aerial view via Google maps. At any given time, visitors to Elahi's Web site can see his most recent

purchases, his most recent telephone calls, photographs of his surroundings, and his current location. He has also compiled an online archive of more than twenty thousand of these photographs—the airports he has slept in, the airline meals he has been served, the toilets he has used, etc. The project, called *Tracking Transience*, serves a real function. If asked about his activities on any given date, Elahi will always be able to give the answer with confidence. If he disappears into indefinite detainment, the world will know. The project also seems to serve some continued purpose for the government, as well: The Web traffic log on trackingtransience.net indicates that people at the Department of Justice and other government agencies are visiting the Web site regularly.

Sharif Waked's video work *Chic Point* (2003) is another response to being treated with suspicion. In it, we see men modeling avant-garde fashions on a catwalk. The clothes are

HASAN ELAHI/
*TRACKING TRANSIENCE:
ALTITUDE V2.0/*
2006/
CHROMOGENIC PRINT/
35 X 28 IN. (87.5 X 70 CM)/

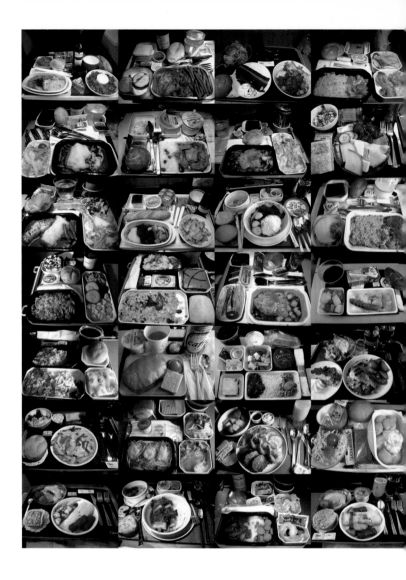

physically revealing: One man wears a dress shirt that zips open at the midriff; another shirt's buttons open at the front, and at the back; other designs expose various body parts through netting, holes, or slits. Following this montage come a series of still photographs that convey the inspiration behind this work: images from Israeli security checkpoints at the West Bank and Gaza, where Palestinian men are forced to disrobe as part of invasive security procedures—lifting their shirts, robes, and jackets, some even kneeling shirtless or naked, with guns pointed at them.

Waked's video facetiously proposes these fashions as a functional response to the practical problem of security checkpoints, a fact of life in Palestine. Instead of being forced to take off a smart jacket or shirt and kneel down in the mud,

HASAN ELAHI/
*TRACKING TRANSIENCE:
INTERSTATE/*
2007/
CHROMOGENIC PRINT
30 X 60 IN. (75 X 150 CM)/

these garments might allow a sharply dressed man to pass inspection without a hem out of place.

The end-users of this line of fashion accessories are imagined as compliant citizens — they are innocent and have nothing to hide. Likewise, *Tracking Transience* is an effective alibi for Elahi because he does not associate with suspected terrorists or spend time in the tribal region of Pakistan. He describes the project as "aggressive compliance."

A frequently cited effect of surveillance is that it can have a chilling effect on people, leading to self-regulation driven by the fear of attracting attention.[12] On one level, Elahi's and Waked's seeming eagerness to proclaim their innocence, and to comply, could be said to represent this chilling effect. These works seem to say, "Survive a suspicious regime by revealing all, hiding nothing, and keeping your nose clean."

Yet both Waked and Elahi add a satirical dimension to their compliance tactics. Their works are modest proposals, highlighting the absurdity of the treatment to which the artists have been subjected. The lengths to which each work suggests one must go to prove one's innocence speak for themselves. They also reverse the power dynamics of the situation: the Israel Defense Forces soldier or F.B.I. agent asking for information is no longer stripping them of their dignity, but complying with the decision of their subjects to reveal all.

RIGHT AND OPPOSITE:/
SHARIF WAKED/
CHIC POINT/
2003/
(VIDEO STILLS)/
SINGLE-CHANNEL VIDEO
WITH SOUND/
5 MINS., 10 SECS./

Chic Point explores the differences between voluntary and involuntary disclosure. In a project by Jill Magid, these forms of disclosure come into sharp contrast.

JULY 22, 2005—NEW YORK, NEW YORK. The New York Metropolitan Transit Authority advises passengers that it will begin making periodic random searches of backpacks and large containers onboard trains and at stations.

WINTER 2006—NEW YORK. Jill Magid returns to the city after living five years abroad. She would later recall, "I rented an apartment in Brooklyn and took the subway often. Everyone is in transit, except the officers. I recently approached one and asked him to search me." The officer she approaches refuses the request, but allows Magid to join him on his next shift, keeping watch on the New York subway.

In romance, unlike surveillance, the exchange of personal information is a two-way process. Jill Magid's work *Lincoln Ocean Victor Eddy* (2006–07) re-imagines the relationship between the individual and the surveillance state as a romantic adventure. The work is a true story, set in a city under constant watch, where all of life seemingly has an official audience.

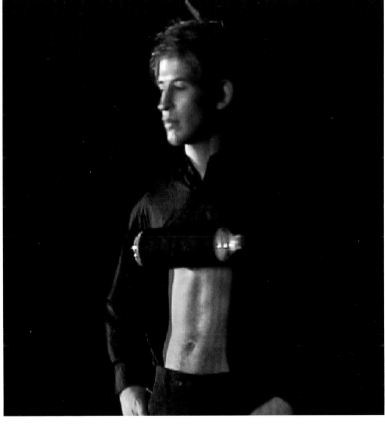

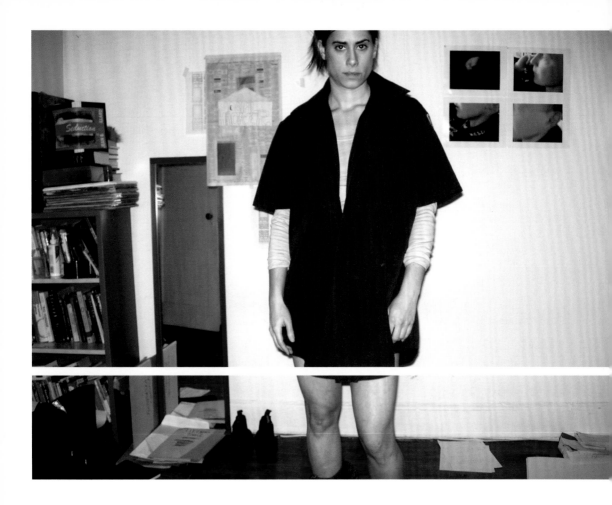

It centers around an unlikely relationship between an artist and an officer, told through photographs, artifacts, and a novella. The novella begins with the story of Magid's initial approach to the officer, and his somewhat bewildered response:

> Will you search me?
> *What?*
> I want you to search me.
> *What?*
> We were rushing across the platform towards the express, and got on just as the door was closing. It was nearly empty but he remained standing, holding the overhead bar.
> *Why do you want me to search you?*
> Because you said you would.
> *I can't search you; you're a woman.*[13]

From these inauspicious beginnings, Magid and the officer would go on to cultivate an unlikely friendship. Although their

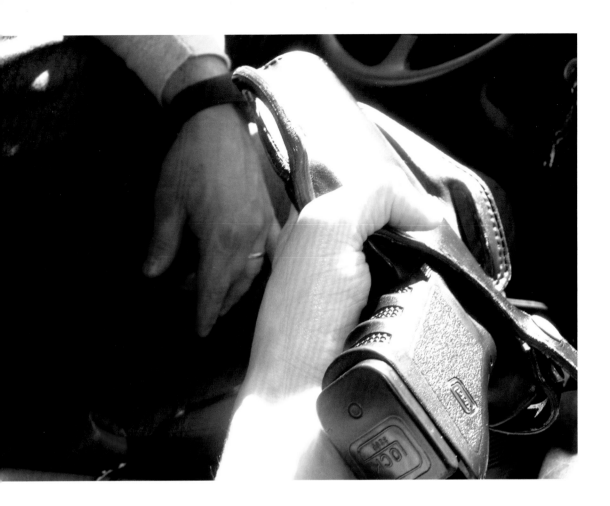

JILL MAGID/
HOLDING HIS GUN FROM
LINCOLN OCEAN VICTOR EDDY/
2007/
CHROMOGENIC PRINT/
21 7/8 X 27 3/8 IN.
(55.6 X 69.5 CM)/

relationship remained platonic, her brazen request to be searched had carried with it the possibility of physical closeness, an unfulfilled promise that would hang over their friendship. As the novella progresses, the exchange of personal information becomes a central part of the story of their growing intimacy.

> I brought him a picture of me in his shirt and two tuna fish sandwiches. He called me the next morning; he'd eaten them both.
>
> *You're wearing something under this, right?*
> Yes, you can see the shirt.
> *It mixes in with your skin.*
> I cropped the picture, but left a small part of my thigh showing. If he studies the picture he might notice. And he might see that his pictures cover the wall behind me.[14]

Magid, on the other hand, is interested in the mundane detail of the officer's life.

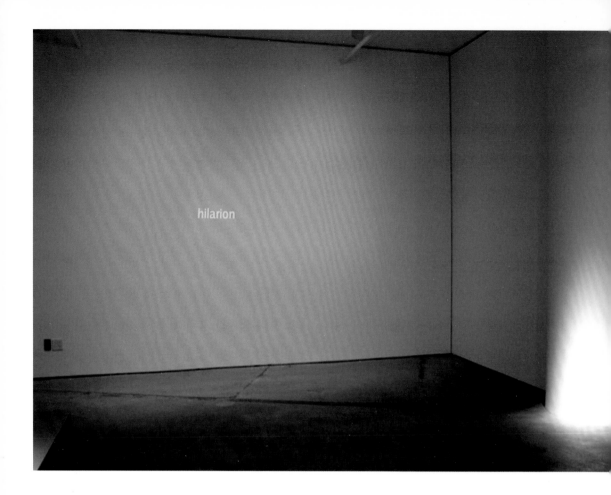

hilarion

I pull out the book in my camera case and begin a passage by Alain Robbe-Grillet: "On the polished wood of the table, the dust has marked the places occupied for awhile—for a few hours, several days, minutes, weeks—by small objects subsequently removed whose outlines are still distinct for some time, a circle, a square, a rectangle, other less simple shapes, some partly overlapping, already blurred or half obliterated by a rag." I look up at him.

He can't follow.
OK, I will read it again.
 I followed but I don't get it. It's boring.
That is the kind of detail I want to know. That much detail.[15]

For Magid, this level of detail is not boring—it is the kind of detail that can never really be captured through surveillance. By exchanging such details, we begin to know and trust others. Through granting small slices of access to their private lives,

Magid and the officer built a fragile alliance within the carefully delimited spaces of his car and the subway platform.

In Magid's work, personal information has value as the currency of intimacy. We exchange it as a way of building trust between people. We often surrender this information to others slowly, over a long period of time, granting them access to our innermost secrets. In our relationships, these transactions are to be treated cautiously. Yet when the interpersonal element is removed, many of us throw this caution to the winds, offering equally intimate information with much less forethought.

DATA SHARING

AUGUST 6, 2006 – The Internet service provider AOL releases information on 20 million Web searches conducted by 650,000 of their users. The users' names are changed to I.D. numbers to protect their identities.

AUGUST 9, 2006 – LILBURN, GEORGIA, U.S. Using anonymous AOL search records, New York Times reporters identify AOL user 4417749 as Georgia resident Thelma Arnold.

Internet searching is a strange behavior, one for which both nature and nurture have left us largely ill-prepared. We often go to the Internet to research our deepest anxieties, looking to the oracle of a search engine for information on subjects that we may feel we cannot ask others about. Ironically, these private rehearsals of anxiety are often less private than we may think. In the mere act of conducting a Web search, we may be disclosing personal information to strangers that we would not tell our closest friends. Consider the example of AOL User #1755639, who searched for the keywords "how to dispose of wife's dead body."

In their networked data-projection piece *Beacon* (2007), Thomson & Craighead make public the semi-private behavior of Internet searching. The piece lists Web searches harvested from search engines around the world, shown in real time. The texts range from the banal ("tire inflation") to the absurd ("flowers that start with a b"). *Beacon* offers the tantalizing prospect of looking into the psyche of anonymous strangers expressing their curiosity, sexual desires, hang-ups, anxieties, and fears with the click of a computer key.

A similar fascination operates in an ongoing work by Jennifer and Kevin McCoy, the *Band Rider Series*, which they began in 2001. These installations are all based on rider agreements—contracts that stipulate the hospitality needs of touring artists, speakers, and musicians—which often attract the keen interest of fans and detractors. They are a reflection of the strange and unchecked appetites of our society's star consumers, rock stars. Each work in the *Band Rider Series* is a full-fledged manifestation of the list of items specified in a rider agreement leaked on the Internet—an assemblage of the foodstuffs and niceties demanded

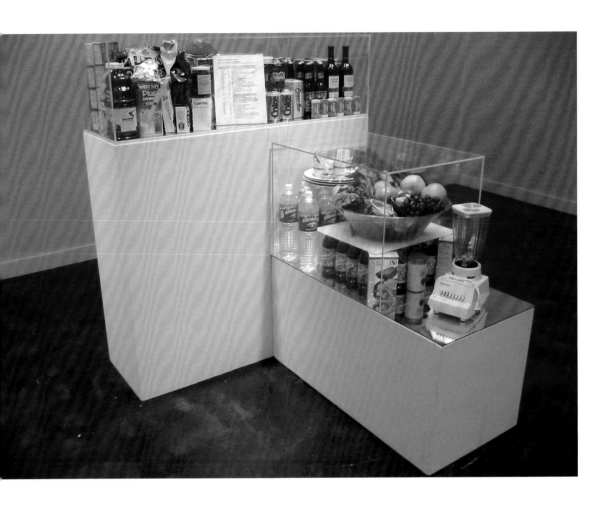

JENNIFER AND KEVIN MCCOY/
BAND RIDER SERIES: NINE
INCH NAILS/
2001/
INSTALLATION WITH TEXT
AND STORE-BOUGHT PRODUCTS/
DIMENSIONS VARIABLE/

by bands such as Nine Inch Nails: Budweiser, Bud Lite, fresh fruit, 6 packs of Extra gum, two boxes of cornstarch (VERY IMPORTANT). For the newest work in the series, the McCoys have created an installation displaying the items in the rider agreement for Dick Cheney's lectures and public appearances. In comparison to NIN, Cheney's requests are spartan: Decaf coffee, caffeine-free Diet Sprite, a queen or king-size bed, and all televisions tuned to Fox News.

Like the *Band Rider Series*, an online project called *Fundrace*, by Eyebeam R&D (Jonah Peretti and Michael Frumin), reflects the implications of the ready availability of personal data on the Internet. Their Web site allows users to type in any postal code in the U.S. and see political donations made by all the people in their area, or to type in the name of a person and see whether that individual donated any money, how much, and to whom — information drawn from records kept by the Federal Election Commission about donations to presidential campaigns or to

JENNIFER AND KEVIN MCCOY/
BAND RIDER SERIES:
DICK CHENEY/
2008/
(DETAIL)/
INSTALLATION WITH TEXT
AND STORE-BOUGHT PRODUCTS/
DIMENSIONS VARIABLE/

VICE PRESIDENTIAL
DOWNTIME REQUIREMENTS

The items listed below are <u>required</u> for The Vice President's Downtime
Suite. Please contact the Advance Office, 202-456-9006, with any questions.

- **Queen or King Size Bed** (in a connecting room to the parlor)
- **Desk with Chair**
- **Private Bathroom**
- **All lights turned on**
- **Temperature set to 68 degrees**
- **All Televisions tuned to FOX News** (please let the Advance
 Office know if it is satellite or cable television)
- **Microwave** - ?
- **Coffee Pot in the Suite** (BREW DECAF PRIOR TO ARRIVAL)
- **Container for Ice** (and the location of where ice maker is located)
- **Bottled Water**, 4-6 bottles
- **Diet Caffeine Free Sprite**, 4 cans
- ~~**Sparkling Water** (Calistoga or Perrier), 2 bottles – if Mrs.
 Cheney is traveling with The Vice President~~
- **Hotel Restaurant Menu** (please also fax a copy to the Advance
 Office, 202-456-7607)

Newspapers - New York Times, USA Today, Wall Street Journal,

If the Hotel would like to put a gift in the Suite please let the Advance
Office know ASAP. Please also make sure someone from the team or a
Super Volunteer (on radio) is there to receive the Motorcade on Arrival.

- extra lamps

the political parties' national committees. For example, I can see
that George Clooney donated $2,300 to Barack Obama in 2007,
and that the owner of the local grocery store in my hometown
gave $500 to John McCain.

The project illustrates how the Web has transformed the
nature of public information. Before the year 2000, campaign
donations were considered a matter of public record. However,
back then, "public" meant that anyone was welcome to pay a visit
to the Federal Election Commission at 999 E St. in Washington,
D.C. and pay $.05 per page for campaign finance records. Today,
these records are still "public," but anyone with a Web browser
can see at a glance whether anyone in their neighborhood con-
tributed to presidential campaigns. In both cases, these records
were public, but on the Internet, they are clearly *more* public.

Information about each one of us can now be found online
in some form. The Internet enables the efficient collection of

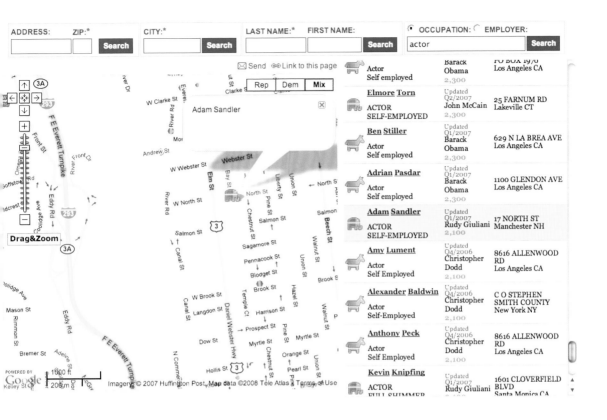

EYEBEAM R&D (JONAH PERETTI
AND MICHAEL FRUMIN)/
FUNDRACE 2008
(NEIGHBOR SEARCH)/
2008/
(SCREEN SHOT)/
COMPUTER INSTALLATION
WITH REAL-TIME
WEB CONNECTION/

personal data, from public records to consumer habits. Once this data is collected, we often have little control over how it is used or how widely it is disseminated. From public records to consumer habits, private information is freely shared and exchanged online, and few individuals are exempt—least of all public figures. In the Internet age, being in the public eye has taken on a whole new meaning.

FEBRUARY 19, 1995—MALIBU, CALIFORNIA, U.S. Model and "Baywatch" actress Pamela Anderson weds former Mötley Crüe drummer Tommy Lee. The couple had known one another for only 96 hours.[16]

SEPTEMBER 1997—MALIBU. A home video of Anderson and Lee's wedding and honeymoon is allegedly stolen from their home.

NOVEMBER 7, 1997— The Internet Entertainment Group airs the tape on their Web site for five hours, resulting in a "cyber traffic jam."[17]

EYEBEAM R&D (JONAH PERETTI
AND MICHAEL FRUMIN)/
*FUNDRACE 2008
(NEIGHBOR SEARCH)/*
2008/
(SCREEN SHOT)/
COMPUTER INSTALLATION
WITH REAL-TIME
WEB CONNECTION/

NOVEMBER 28, 1998 – A federal judge dismisses Anderson and Lee's lawsuit against the Internet Entertainment Group, giving the company the green light to continue distributing the video under the title *Stolen Honeymoon* (1998).

For his piece *Home Video II* (2007), artist Kota Ezawa re-created selected scenes from *Stolen Honeymoon* in a digital animation program. His animation style translates each object into a field of solid color, and renders any motion with mathematical precision.

Ezawa's re-painting de-emphasizes the content of the video while drawing particular attention to the style in which the video is shot. The smooth motion highlights Anderson and Lee's camera work, which betrays an unbridled enthusiasm for zooming and panning. Similarly, Ezawa's use of color fields highlights a scene in which Anderson and Lee play with an orange filter, placing it in front of the lens to change the color of the images. There is one short sequence chosen by Ezawa that betrays some knowledge of filmmaking. In this sequence, Pamela stares off-camera for several moments. In the next shot, we see what we assume to be the object of her attention: the dog, who is staring back at Pamela

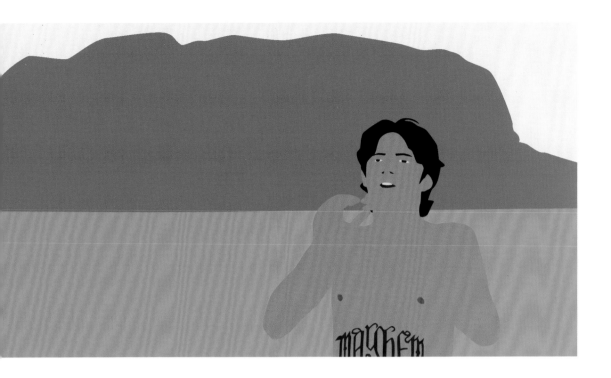

KOTA EZAWA/
HOME VIDEO II/
2007/
(VIDEO STILL)/
SINGLE-CHANNEL VIDEO
WITHOUT SOUND/
5 MINS./

in a perfect eyeline match. After a moment, the dog—with perfect comic timing—sticks out his tongue at Pamela. A few seconds later, we see Tommy Lee walk through the frame. With both Anderson and Lee appearing on camera, it seems that this shot/reverse shot sequence must have been the work of a third party.

Despite the notoriety and media savvy of its makers, *Stolen Honeymoon* was made strictly within the aesthetic conventions of home video. In Ezawa's hands, the tape's true revelation is not the particulars of Anderson and Lee's relationship; instead, it is Anderson and Lee's relationship with the camera. This is a film about two people learning to make movies, an exploration of the amateur aesthetic. After its release, Anderson and Lee fought the distributor in court, but speculation abounded that the release of the video was a calculated publicity stunt. In the face of such speculation, it was the tape's sheer amateurishness that lent it authenticity, that gave it the feeling of being a glimpse behind the heavily filtered curtain of celebrity.

THE NEW NORMAL

Privacy debates in the late 1990s centered around the rise of security cameras in public spaces, but the debate has shifted over the past several years to emphasize online and electronic privacy

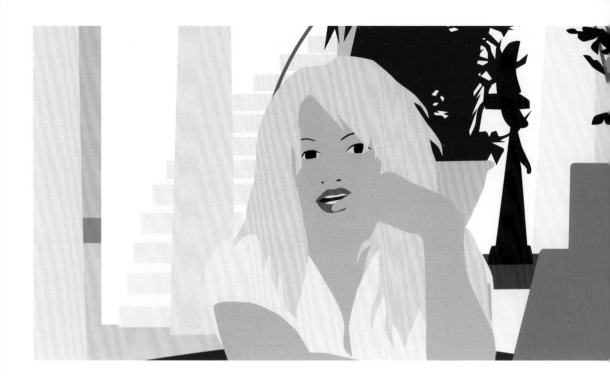

ABOVE AND OPPOSITE:/
KOTA EZAWA/
HOME VIDEO II/
2007/
(VIDEO STILLS)/
SINGLE-CHANNEL VIDEO
WITHOUT SOUND/
5 MINS./

issues. While data collection by governments and corporations has sparked strident debate, the rise of surveillance has been equaled in scope by the parallel rise in self-disclosure. We make decisions every day to share information about ourselves for the sake of convenience, or because our social lives are increasingly taking place in the online sphere.

The works presented in *The New Normal* use the strategy of disclosure as a tool for satire and critique. They reflect on the changing social conventions that govern the boundaries between public and private spheres, and they make visible the aesthetic codes that characterize this culture of confession. Taken as a whole, *The New Normal* imparts the idea that access to private information is a kind of currency. The creation and exchange of this currency is growing and evolving. We all have a stake in this exchange: we may find it frightening or fascinating, but we are inescapably complicit in its perpetuation.

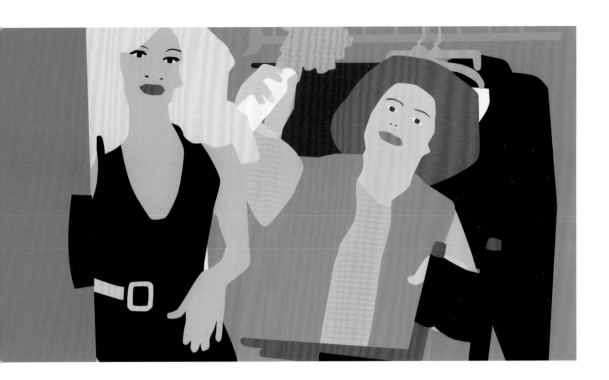

1. "Amazon.com Launches Millions of Tabs, Featuring a Store for Every Customer,"
 Business Wire, September 27, 2001, www.thefreelibrary.com, accessed January 13, 2008.

2. http://www.whitehouse.gov/vicepresident/news-speeches/speeches/vp20011025.html,
 accessed January 13, 2008.

3. http://www.kodak.com/US/en/corp/kodakHistory/buildingTheFoundation.shtml,
 accessed February 24, 2008.

4. Samuel Warren and Louis Brandeis, "The Right to Privacy," *Harvard Law Review* 4,
 no. 193 (1890)

5. This definition of privacy is based on Jerry Kang, "Information Privacy in Cyberspace
 Transactions," *Stanford Law Review* 50 (1998): 1193–1294.

6. Stephen Grey, *Ghost Plane: The True Story of the CIA Torture Program* (New York: St. Martin's
 Press, 2006), p. 195.

7. Ibid., p. 211.

8. Sophie Calle, *M'as-tu vue?* (Munich: Prestel Verlag, 2003), p. 418.

9. Andre Magnin, "Seydou Keita," *African Arts* 28, no. 4 (1995): p. 95.

10. http://www.arte.tv/fr/cinema-fiction/Court-circuit/27-avril/774732,CmC=784480.html,
 accessed January 13, 2008.

11. Catharine A. MacKinnon, *Toward a Feminist Theory of the State* (Cambridge, Mass.: Harvard
 University Press, 1989), p. 169.

12. Daniel Solove, "A Taxonomy of Privacy," *University of Pennsylvania Law Review* 154 (2006):487.

13. Jill Magid, *Lincoln, Ocean, Victor, Eddy* (New York: Jill Magid, 2007), p. 1.

14. Ibid., p. 8.

15. Ibid., p. 13.

16. http://www.people.com/people/pamela_anderson/biography, accessed February 12, 2008.

17. "Pamela Anderson Lee, Husband Drop Try at Halting Video Showing," *Seattle
 Post-Intelligencer*, December 4, 1997.

Private, Public, and the Collapse
of the Personal

CLAY SHIRKY

The big change in privacy in our current social environment isn't a simple decay, from more to less. It is instead a change from privacy as part of that environment to privacy as an affirmative right, one that must be negotiated with every merchant and every government agency and even every friend whose life touches ours. How that haggling gets resolved—with businesses, with the government, and within our social network—is in many ways less momentous than the emergence of privacy as something that has to be haggled over at all.

It was not always this way. Back in the technological dark ages (circa 1980, say) the public and private sphere were separated by a wide gulf, enabling one to engage in behavior that was observable in principle but unobserved in practice, a gulf we might call "personal" (a word that has fallen into recent disuse, except as a label for certain electronic gadgets). In those days, there were microphones and cameras and computers, all of which provided a mechanism for fixing evanescent thoughts or actions into a storable form, but its potential remained untapped for most citizens.

Then as now, we had a notion that our love letters or medical data were rightly defended from casual view, but unlike now, we could also assume that our behavior wasn't being recorded when we confided in our friends or joked with our colleagues or even walked down the street. Technological possibility had not yet become technological reality—our personal behaviors weren't private, in the sense of being actively hidden, nor were they public, in the sense of being readily and cheaply available to all. In that era, most of our unobserved behavior wasn't concealed—it was just ignored; the principal guarantor of privacy wasn't rights or privileges, it was the sheer inconvenience of trying to capture every bit of information about everybody.

And now it is pretty easy to do that, and getting easier every day. In the generation between then and now, several major shifts have occurred. The first was what always happens to technology: it got cheaper and more effective at the same time. The cost of absolutely every form of information capture has plummeted. Cameras are so cheap they are added to phones as a freebie. Video

surveillance is no longer found only in banks but is now a common feature of nearly every store, small or large. The most trivial utterances around the water cooler are sent through the ether and stored, almost by accident, alongside the wisdom of the ages.

As the cost of capture and storage has fallen, the ease of re-transmission has increased and spread. Your ability to recount verbally what a friend told you over dinner is unreliable — you could be misremembering or dramatizing your friend's utterances in the re-telling. However, your ability to republish exactly what a friend told you in an e-mail is effortless and the result is perfectly accurate; it would be accepted as evidence in a court of law.

It used to take considerable effort just to try to make something public. The old phrase "Shout it from the rooftops" conjures up some of the ad hoc and impractical nature of an individual citizen emulating a media outlet. Now, everyone with a computer or a phone has been given both a rooftop and a megaphone. The costs to an individual citizen to make something public, measured not just in expense but in time and risk, have fallen so far that the key question of publishing information has been reversed. When doing so was expensive and relatively rare, the question was simple: "Why publish this?" As almost anyone can now become an accidental publisher, the question is now the opposite: "Why not publish this?" Photo sharing is the canonical example, depending as it does on the billions of cheap cameras and camera phones in the hands of the public. With the resulting high volume of photos sent and received each day, it is easier to share all of them than to edit out the boring or disclosing shots in advance. Just upload it all and sort it out someday, or never; why not?

As making things public has become cheaper and easier, keeping things private has become harder and more expensive. If you had a paper document you wanted to keep out of the public eye, simple inaction was usually enough: just put it on a shelf instead of handing it around. There were always places where more security was needed (trade secrets and spies' identities and the location of buried treasure have always required heightened vigilance), but for most people, keeping our private information private required no heroic effort. Now, however, our

most reflexive actions — which used to remain unequivocally in our personal sphere — increasingly fall into either the easily public or the expensively private sphere. Consider, as a thought experiment, trying to walk without being photographed from, say, the Empire State Building to the Lower East Side, or to drive from Buckingham Palace to Brick Lane without a surveillance camera recording your car's license plate. It's impossible even to imagine such a thing without the aid of some form of intentional cloaking.

In the same way we have all become accidental publishers, we have all become accidental archivists. Just as social networks and weblogs flip the question of publishing from "Why publish this?" to "Why not?," the availability of cheap storage flips the question of whether to save information from "Why keep this?" to "Why throw this away?" Consider the problem of sending e-mail to a friend when you want its contents not to spread any further than that friend. You can no longer rely on simple inconvenience to aid you in keeping the information confidential; it all falls to your friend's discretion over what you've shared,

and the ease and accuracy of sending digital information weakens this defense. Friendships can fade or even dissolve over the years (with deeper secrets and more intense reversals applying *a fortiori* to lovers' confidences), but a perfect record often remains of every word you said. This record may outlast the relationship, ready to be copied a million times at no cost and in the blink of an eye, should the rest of the world come to care about what you said.

The most recent growth in accidental archives is occurring via the telephone. Marshall McLuhan's dictum that the contents of the new medium are the old media is coming true, again, as the Internet carries more and more of our phone calls. When our voices are digitized, those digital recordings of what we have said can also be stored, often for the best of reasons. This form of transmitting messages is as reproducible as e-mail while preserving the more emotional content of human speech, and puts the technology for making, saving, and/or sending those voice recordings in the hands of ordinary people. Calls used to be recorded only by institutions — by businesses, "for quality-assurance

purposes," or by the police, for other purposes —but phone calls transmitted over the Internet are now being recorded by individuals, for later reference, for pure sentiment, or merely because they don't know what might matter to them in the future. Given the continued fall in the cost of digital storage and the continual rise in the cost of human time, it is now cheaper to keep things by accident than to delete them on purpose. Having a conversation that isn't being archived, whether deliberately or not, is becoming as rare as passing through town without being photographed.

Making things public has gone from difficult to easy and from expensive to cheap. Keeping things private has gone in the opposite direction. And the personal sphere—which used to be the envelope that contained most of our speech and action—is slowly disappearing. In many of the current arguments around privacy, and especially privacy in the market, much of the discussion is around informed consent by the users, and the question of opt in vs. opt out. Should your doctor share your medical records? Should Facebook tell the world you just bought a new pair of shoes? Yes or no? But beyond yes

or no, there is, or was, a third option: Don't ask. By the time the conversation has rolled around to opting in vs. opting out, the collapse of the personal sphere has already taken place.

The stories we hear about the loss of privacy are usually about a particular loss—identity theft, say, or unwanted disclosure. Much harder to quantify is the general loss, not of the right to privacy but rather of the right not to have to think about our privacy, the right to take for granted some large sphere of observable but unobserved speech and action. That era is already a dim memory for those of us who live in cities geared for high-tech communication, and it is fading everywhere, if only because the public access to satellite photography brings even the least digital among us into the world of recorded action.

This change is not limited to any narrow definition of privacy; when showing information is cheap and hiding it is expensive, it transforms all kinds of ancillary relationships. One example of this collateral change is the way our conception of the whistle-blower has altered in the last several years. In 2001, an Enron accountant,

Sherron Watkins, sent e-mail to a handful of executives at Enron entitled "Smoking guns you can't extinguish," detailing the suspect practices that Enron was using to hide the company's liabilities. As she put it, presciently: "I am incredibly nervous that we will implode in a wave of accounting scandals," which is exactly what happened the following year. Watkins was widely described as a whistle-blower, even though her e-mail was addressed to only a few insiders. Unlike any previous whistle-blower, all she did was write a particularly forceful inter-office memo. Watkins didn't in fact take anything private and make it public; the act of her e-mail becoming public took place months after the fact, when lawyers were searching Enron's e-mail archives.

The application of the whistle-blower label to Watkins signals that in an age where copying information can be done infinitely and exactly, the very act of documenting and sharing something can be a threat to privacy: once data is shared, it is almost impossible to destroy all the copies, and anyone who has a copy can effortlessly broadcast it to the world at will. One may presume that from now on, the act of creating and circulating evidence of wrongdoing, even among a small group, will be regarded as a public act.

This is the kind of transformation that makes privacy impossible to frame as a single concept that persists across historical ages. For anyone contemplating the aesthetic, social, or historical dimensions of privacy, what may be toughest to grasp isn't the technological transformation of the current era (which has already been documented in tedious detail), but rather the emotional and social transformations that it creates. It is becoming harder to remember what it felt like to live at a time when privacy was easy to get and difficult to violate, and when we could expect that most of our behavior would be kept from public awareness. (For a teenager today, that world is already as distant as the Watergate scandal or the fall of the Berlin Wall.)

This coarsening of the world into public or private, and the collapse of the barriers between them, has led to a much-discussed generation gap. People under thirty or so, for whom digital tools are matter-of-fact, even boring, are often described as caring less about their own privacy than their elders do, and as being less inhibited

and more exhibitionistic. Most of the discussion about this is being done by those very elders, and their descriptions tend toward the value-laden: "When I was young, we didn't tell the world about our most recent trip to the mall! We didn't put party pictures of ourselves out where our bosses could see!" The behavior of the world's callow youth is framed as a personal failing, a shift in behavior from the good old Right Way (our way) to a bad new Wrong Way (theirs).

But what if the change in behavior is an effect, not a cause? While it's tempting for those of us who are Of a Certain Age (a label that is now closer to thirty-five than fifty) to attribute novel and upsetting behaviors to a lack of common sense among our juniors, the truth is more banal: It wasn't forbearance that kept us from making our lives public when we were in our twenties—we didn't share our party pictures or random thoughts with the world because we never had the opportunity. These twenty-somethings are the same kind of people we were, but responding to a different kind of incentive.

They are also responding to a different kind of threat. Much of the what has been described as self-disclosure is in fact disclosure by others. When every one of your friends has a camera phone, having your image transmitted to the public at large, or not, isn't necessarily your own personal decision to make. When the act of texting messages to your friends (and vice versa) creates a permanent and easily publishable record, you give up the option to defend your privacy unilaterally; perhaps the only way to restore this control to you would be to drop out of society.

Because we usually change our actions when we are being observed, the re-creation of privacy as a rare and expensive commodity produces behavior modification on a societal scale. We have built the panopticon, and it is us. If people today are acting out more, it is in part because they understand, correctly, that they are onstage more. This is a form of governance, as depicted in George Orwell's canonical novel *1984*; but what Orwell didn't predict was that governance does not require Government. It turns out that ubiquitous observation is best achieved through ubiquitous observing, and social and market forces are better at driving that sort of change.

Pascal Boyer, in his brilliant book *Religion Explained*, notes that one of the commonalities of religious belief, whether mono- or polytheistic, is that supernatural agents have access to strategic information (thus confirming H. L. Mencken's observation "Conscience is the inner voice that warns us somebody may be looking"). All religions, with or without an omniscient god, imagine spirits of some sort who can see what we are doing, even when we are alone. The gods are not real, of course, so this inner voice used to be wrong most of the time, but not anymore. One might describe as "godlike" the access that almost anyone has nowadays to strategic information about others; the number of people who may be looking, and the number of times they look, are growing by the day, often as much a side effect of us digitizing our lives as of other people setting out to observe us.

Thus, it falls to those of us wrestling with the current changes to deal with the metamorphosis of privacy from something we took for granted to something each individual has to consider almost daily. The hardest part of documenting and describing this change will be figuring out how to convey, to our peers and our descendants, just how weird things have gotten.

The Unreality Clause

MARISA OLSON

wrote this essay late—much to the dismay of the book's editors. I did so largely because I felt some anxiety about the first word in the essay: "I." When *The New Normal*'s curator, Michael Connor, asked me to contribute an essay, he encouraged me to "make the leap to first person" and write about privacy and self-surveillance from the perspective of my own work as an artist. Ironically, for someone whose work often has the surface appearance of self-absorption and frequently revolves around public confession, I hesitated. I was taught that one does not insert oneself into critical essays, no matter how subjective the material. There is a time and place to talk about oneself, and this isn't it.

Of course, as I understand it, the fear of writing for print in the first person is a particularly American qualm. I once read an essay by Italian semiotician Umberto Eco in which he said that Americans were baffled by the ways in which his work straddled academia, fiction, and social commentary on popular culture, whereas in Europe it was almost an obligation for intellectuals to comment publicly on the habits and customs of mainstream society. This position

necessitates writing in the first person—taking responsibility for one's words. Of course, such a commitment seems specific to print media. Authors of commentary published online often hide behind the veil of anonymity, or the specter of unreality: an author who does not adopt a pseudonymous screen name always has the option of claiming her expressions to be fictive.

Mediated communication and performative genres are similar in enabling us to leave the question of reality somewhat ambiguous (what pseudo-pundit Stephen Colbert has termed "truthiness"—relying on personal perceptions and feelings rather than facts to determine what is true). Ultimately, artists and authors are afforded the opportunity to keep things murky, with regard to the honesty of the utterances that occur within these spaces—whether because we can always wield the phrase "it's all a performance," like some kind of Get Out of Jail Free Card, or because they can exploit our common tendency to question the reality of anything "digital." (At least as long as this tendency to question digital indexicality perseveres.) I call this The Unreality Clause.

Despite the fact that whole cultures are built around the practice of confession, confessing isn't easy. For that matter, being oneself isn't always easy. Both subject the individual to scrutiny and to the prospect of rejection and failure. The institution of confession was once built around a one-to-one communication model. The confessee and confessor were interlocutors in a private exchange marked by a traditional commitment to confidentiality. This is, in so many ways, exactly the opposite of what we see in network culture and in much great performance art. I suspect that the two have changed for similar reasons.

My own performance work often entails confessional blogs, videos, or slide lectures. I remember vividly the slide lecture that helped me arrive at the epiphany that private confession was much more difficult for me than public displays of awkwardness. Pacific Film Archive curator Steve Seid knew that I had a strong interest in the cultural history of technology, and he closely followed "Marisa's American Idol Audition Training Blog," my online diary in which I self-deprecatingly charted my attempt to prep for the huge televised talent contest. Seid invited me to develop a performance related to telephones, to be sandwiched between a screening of two video works, Christian Marclay's *Telephones* (1995) and Andy Warhol's *Phoney* (1973). I decided to create a slide lecture called *What My Telephones Knew About Me*, which would be an autobiographical account of all the embarrassing personal stories my previous phones could tell about me, if they could talk. This was a bulleted list of funny and/or painful things I'd told people over the phone.

Despite my excitement about sharing the bill with two of my all-time favorite artists, I didn't invite anyone I knew to this performance. Strangers were one thing; I didn't want any of my friends to hear my stories, which ranged from my accidental calls to 911 when I was a kid to the phone sex I had in my twenties. One friend heard about the upcoming performance and came anyway. He sat next to me during the Marclay screening and I kept warning him that he was about to learn a lot more about me. "What could I learn that would be bad?" he asked. He sat through the performance with his

jaw agape. His eyes widened as I talked about the phone call in which I told my mom I'd never speak to her again, and the one four years later in which I told her I.C.U. nurse all the things I wanted her to know before they pulled the plug. And there was more. It was personal, intimate. My friend freaked out. But I felt great. It was so much easier to look at all the foreheads in that packed theater as a sea of anonymous people than it ever would have been to express these thoughts to a single individual. If I were dealing with only one listener, I'd be thinking about that person's subjective reactions and how they would affect his or her response to my confessions—i.e., judgments about me.

Communicating to a group leaves the actor (the speaker) open to increased scrutiny, and yet manages to create a false sense of anonymity. It's like a reverse panopticon: I know I'm being looked at by everyone (potentially), so I stop worrying about what any one person will think of me. Besides, I can always invoke The Unreality Clause. Admitting this to you now makes me feel neurotic—but then again, I have no idea who's reading this, so it's OK.

The same goes for video broadcasts and blogging. In fact, the Internet takes this whole issue to another level. Anyone who participates in media culture—that is, reads the news, watches TV, listens to the radio, or surfs the Net—has undoubtedly heard about the proliferation of blogs and the fact that our ideas about privacy are shifting. I'm not sure whether this is good or bad, but it's certainly interesting.

Whatever one thinks of what's going on, the politics of privacy are being re-formulated. Our system of civil law used to maintain a high valuation of the "right to privacy." Now we have illegal wiretapping by the federal government; but we're not told who's being spied upon—it could be any of us, and anyone could be listening. And we're complicit in this. We New Yorkers who ride the subway are told repeatedly that we're subject to random search (technically, it's voluntary, but we're not reminded of that), while the recently coined mantra "If You See Something, Say Something" is disseminated via loudspeaker announcements and advertising posters, impelling many of us to internalize the message. So we're spying on our neighbors

as members of a new culture of fear. Perhaps retaining control over "squealing" by doing it "voluntarily" allows us to believe that this terror, too, is unreal. Perhaps it is.

But if you look at the numbers, very few people have actually "seen something" and then "said something." These instances of sanctioned spying that result in one-to-one testimony to representatives of the State are eclipsed by the countless acts of speech occurring online every day on blogs and in anonymous forums, and by the covert spying via mobile devices that track our whereabouts and consumption patterns. In many ways, it's the outgrowth of a trend that some call narcissism. The Pew Research Center for the People and the Press recently released a report about "Generation Next" (the children of the "Me" generation), characterizing these 18-to-25-year-olds as the "Look at Me" generation. The slight evolution, here, is that the members of this younger generation who have grown up online are not only self-obsessed—they are self-broadcasting.

We've seen that there is such a thing as becoming "Internet famous." It would be easy to say that this is a form of fame less "real" than offline fame, but that would be to dismiss the fabrication that is at the heart of all fame. Internet fame is most often the result of "memes" that spread like viruses. A meme is an entity that grows in a self-replicating manner, asexually— that is, its growth does not require the specific participation of another. Ironically, both online and in the controversial realm of genetic theory in which the meme is a player, control of its evolution is handed over to the masses: in the latter, to the human culture that adopts a genetic trait and, in the former, to the Net surfers who make a video, joke, or news story popular. There is something unreal about this, too. And yet it happens. Web stats prove it.

Adrift on the open sea of the Web, private moments engender identities and propel culture precisely because the Internet is a public space—that is, because the idea of online anonymity is illusory. This is the truth none of us confesses even to ourselves, because the high level of mediation involved in such expression convinces us to regard the mesh of the Web as a safety net.

However, the narcissism that the "Look at Me" generation feels safe to explore is selfish in a natural way — perhaps even in an "evolved" way. Psychoanalytic descriptions and discussions of narcissism emphasize that the disorder is not a love of oneself, but an obsession with one's image. Ironically, new media enable people to distance themselves from these images by broadcasting more of them. The value of this currency changes when the market is flooded with it, and when we become the "banker" in control of this output, we can set the terms of symbolic exchange. Why would so many people turn the camera (or the pen or the computer keyboard) on themselves and publish the results online? The answer might be that it allows these individuals to regulate public perception of themselves more tightly in a world in which each of us is lost in a vast population that is always-already subject to the scrutiny of others, be it by our friends, our idols, or the State.

Mass media allow us to craft our image to our own specifications and, if we so desire, to distance ourselves from our self-image. Remember that images, too, are subject to The Unreality Clause. This is the cornerstone of representation, and unlike the telecommunications devices that continue to evolve and work their ways in and out of our lives, it's nothing new.

Bibliography

SELECTED READING BY AND ABOUT THE ARTISTS

Calle, Sophie. *M'as-tu vue?* Munich: Prestel Verlag, 2003.

Fletcher, Harrell and Miranda July. *Learning to Love You More*. New York: Prestel USA, 2007.

Lovink, Geert. "Surveillance, Performance, Self-Surveillance: Interview with Jill Magid." *Nettime-l*. 2004. http://www.mail-archive.com/nettime-l@bbs.thing.net/msg02266.html

Magid, Jill. *Lincoln, Ocean, Victor, Eddy*. New York: Jill Magid, 2007.

Paglen, Trevor and A.C. Thompson. *Torture Taxi: On the Trail of the CIA's Rendition Flights*. Brooklyn: Melville House, 2006.

Waked, Sharif. *Chic Point: Fashion for the Israeli Checkpoints*. Tel Aviv: Andalus, 2007.

Zuckerman, Ethan. "Tracking Hasan Elahi." *WorldChanging*. 2006. http://www.worldchanging.com/archives/005105.html

ABOUT PRIVACY

Barbaro, Michael and Tom Zeller. "A Face Is Exposed for AOL Searcher No. 4417749." *New York Times*, August 9, 2006.

Baron, Rebecca. "How Little We Know of Our Neighbors: Mass-Observation and the Meaning of Everyday Life." *Cabinet Magazine* 15 (Autumn 2004).

Bentham, Jeremy. *The Panopticon Writings*. Ed. Miran Bozovic. London: Verso, 1995.

Boyd, Danah. "Why Youth (Heart) Social Network Sites: The Role of Networked Publics in Teenage Social Life." *MacArthur Foundation Series on Digital Learning—Youth, Identity, and Digital Media Volume*. Ed. David Buckingham. Cambridge, Mass.: M.I.T. Press, 2007.

Boyd, Danah. "Controlling Your Public Appearance." www.zephoria.org, September 7, 2007. http://www.zephoria.org/thoughts/archives/2007/09/07/controlling_you.html

Bromwich, David. "How Publicity Makes People Real." *Social Research* 68, no. 1 (Spring 2001): 145–72.

Cohen, Adam. "One Friend Facebook Hasn't Made Yet: Privacy Rights." *New York Times*, February 18, 2008.

Conan Doyle, Sir Arthur. "A Case of Identity." *The Adventures of Sherlock Holmes*. Oxford: Oxford University Press, 1998, pp. 30–48; repr. of orig. ed., London, 1892.

Deleuze, Gilles. "Postscript on the Societies of Control," *October* 59 (Winter 1992): 3–7.

Foucault, Michel. *Discipline & Punish: The Birth of the Prison*. New York: Vintage Books, 1995.

Goffman, Erving. *The Presentation of Self in Everyday Life*. New York: Doubleday, 1959.

Greenfield, Adam. *Everyware: The Dawning Age of Ubiquitous Computing*. Berkeley, Calif.: New Riders Press, 2006.

Kang, Jerry. "Information Privacy in Cyberspace Transactions." *Stanford Law Review* 50 (1998): 1193–1294.

Lester, Toby. "The Reinvention of Privacy." *Atlantic Monthly*, March 2001.

Levin, Thomas Y., Ursula Frohne and Peter Weibel, eds. *CTRL [SPACE]: Rhetorics of Surveillance from Bentham to Big Brother*. Cambridge, Mass.: M.I.T. Press, 2002.

MacKinnon, Catharine A. *Toward a Feminist Theory of the State*. Cambridge, Mass.: Harvard University Press, 1989.

Mann, Steve. "Equiveillance: The Equilibrium between Sur-veillance and Sous-veillance" (pre-conference workshop text for a panel discussion at the May 2005 conference of the Association of Computing Machinery: Computers, Freedom and Privacy). http://wearcam.org/anonequity.htm

Marx, Gary T. "Murky Conceptual Waters: The Public and the Private." *Ethics and Information Technology* 3, no. 3 (2001): 157–69 .

McGrath, John E. *Loving Big Brother: Performance, Privacy and Surveillance Space*. New York: Routledge, 2004.

Mead, Margaret. *Coming of Age in Samoa*. New York: Perennial Classics, 2001.

Nagel, Thomas. *Concealment and Exposure, and Other Essays*. Oxford, Eng.: Oxford University Press, 2002.

Nissenbaum, Helen F., "Privacy as Contextual Integrity." *Washington Law Review* 79, no. 1 (2004). http://ssrn.com/abstract=534622

Salecl, Renata. "The Exposure of Privacy in Today's Culture." *Social Research* 69, no. 1 (Spring 2002).

Schulhofer, Stephen. *The Enemy Within: Intelligence Gathering, Law Enforcement, and Civil Liberties in the Wake of September 11*. New York: Century Foundation Press, 2002.

Solove, Daniel. "Of Privacy and Poop: Norm Enforcement via the Blogosphere" (column on *Balkinization* blog, June 30, 2005). http://balkin.blogspot.com/2005/06/of-privacy-and-poop-norm-enforcement.html

Sterling, Bruce. "Remarks at Computers, Freedom and Privacy Conference IV, Chicago, March 26, 1994." http://w2.eff.org/Misc/Publications/Bruce_Sterling/cfp_94_sterling.speech

Stocker, Gerfried and Christine Schöpf, eds. *Ars Electronica 2007: Goodbye Privacy —Welcome to the Brave New World*. Ostfildern, Germany: Hatje Cantz, 2007.

Taipale, K. A. "Technology, Security and Privacy: The Fear of Frankenstein, the Mythology of Privacy and the Lessons of King Ludd." *Yale Journal of Law and Technology* 7, no. 123 (December 2004).

Tamás, Yaman. "Anonymity, Democracy, Cyberspace." *Social Research* 69, no. 1 (Spring 2002).

Viégas, Fernanda B. "Bloggers' Expectations of Privacy and Accountability: An Initial Survey." *Journal of Computer–Mediated Communication* 10, no. 3 (2005), article 12.

Warren, Samuel D. and Louis D. Brandeis. "The Right to Privacy." *Harvard Law Review* 4 (1890): 193–220.

Exhibition Checklist

SOPHIE CALLE
BORN 1953, PARIS, FRANCE
LIVES IN PARIS
Unfinished, 2005
Single-channel video with sound
30 mins., 14 secs.
Courtesy Electronic Arts Intermix (EAI), New York

MOHAMED CAMARA
BORN 1983, BAMAKO, MALI
LIVES IN PARIS AND BAMAKO
Les Rideaux de Mohamed
(*The Curtains of Mohamed*), 2004
Single-channel video without sound
65 mins.
Collection of the artist, courtesy
Galerie Pierre Brullé, Paris

HASAN ELAHI
BORN 1972, RANGPUR, BANGLADESH
LIVES IN NEW BRUNSWICK, NEW JERSEY
Tracking Transience: Position and *Tracking Transience: Evidence*, 2007
Two-channel video without sound and
single-channel video without sound
Collection of the artist

EYEBEAM R&D/JONAH PERETTI
AND MICHAEL FRUMIN
BORN 1974, OAKLAND, CALIFORNIA;
1978, BROOKLYN, NEW YORK
LIVE IN NEW YORK CITY AND
SOMERVILLE, MASSACHUSETTS
Fundrace 2008 (Neighbor Search), 2008
Computer installation with real-time
Web connection
Dimensions variable
Courtesy of Eyebeam R&D Lab, Jonah Peretti,
Michael Frumin, and Huffington Post

KOTA EZAWA
BORN 1969, COLOGNE, GERMANY
LIVES IN SAN FRANCISCO, CALIFORNIA
Home Video II, 2007
Single-channel video without sound
5 mins.
Courtesy the artist and Murray Guy, New York

MIRANDA JULY AND HARRELL FLETCHER
BORN 1974, BARRE, VERMONT;
1967, SANTA MARIA, CALIFORNIA
LIVE IN LOS ANGELES, CALIFORNIA;
PORTLAND, OREGON
Learning to Love You More (Assignment 50: Take a flash photo under your bed), 2005
Color photographs printed from Internet
project with text labels
Each, 4 x 6 in. (10.2 x 15.2 cm)
Courtesy the artists

GUTHRIE LONERGAN
BORN 1984, LOS ANGELES, CALIFORNIA
LIVES IN LOS ANGELES
MySpace Intro Playlist, 2006
Two single-channel videos with sound
8 mins.; 13 mins.
Courtesy the artist

JILL MAGID
BORN 1973, BRIDGEPORT, CONNECTICUT
LIVES IN AMSTERDAM AND NEW YORK CITY
Lincoln Ocean Victor Eddy, 2006–07
Single-channel video without sound,
three Chromogenic prints, book, copy
of bullet in bulletproof vitrine
12 mins., 49 secs.
Vitrine: 12 x 12 x 12 in. (30.5 x 30.5 x 30.5 cm);
prints: 21 $^7/_8$ x 27 $^3/_8$ in. (55.6 x 69.5 cm);
21 $^7/_8$ x 32 $^3/_8$ in. (55.6 x 82.2 cm);
and 33 $^1/_2$ x 47 in. (85.1 x 119.4 cm)
Courtesy Yvon Lambert Gallery, New York

JENNIFER AND KEVIN MCCOY
BORN 1968, SACRAMENTO, CALIFORNIA;
1965, SEATTLE, WASHINGTON
LIVE IN NEW YORK CITY
Band Rider Series: Dick Cheney, 2008
Installation with text and store-bought products
Dimensions variable
Courtesy Postmasters Gallery, New York

TREVOR PAGLEN
BORN 1974, WASHINGTON, D.C.
LIVES IN BERKELEY, CALIFORNIA
Six C.I.A. Officers Wanted in Connection with the Abduction of Abu Omar from Milan, Italy, 2007
Six inkjet prints
Each, 14 $^5/_8$ x 14 $^5/_8$ in. (37.1 x 37.1 cm), framed
Courtesy the artist and Bellwether Gallery,
New York

CORINNA SCHNITT
BORN 1964, DUISBURG, GERMANY
LIVES IN COLOGNE, GERMANY
Once Upon a Time, 2005
Single-channel video with sound
25 mins.
Courtesy Gallery Olaf Stueber, Berlin

THOMSON & CRAIGHEAD
JON THOMSON: BORN 1969,
LONDON, ENGLAND;
ALISON CRAIGHEAD: BORN 1971,
ABERDEEN, SCOTLAND
LIVE IN LONDON
Beacon, 2007
Data projection with real-time Web connection
Dimensions variable
Collection of the artists

SHARIF WAKED
BORN 1964, NAZARETH, ISRAEL
LIVES IN HAIFA, ISRAEL
Chic Point, 2003
Single-channel video with sound
5 mins., 10 secs.
Collection of the artist

Photography Credits

Cover: courtesy Kota Ezawa and Murray Guy, New York; p. 2: courtesy Hasan Elahi; p. 6: courtesy Thomson & Craighead; pp. 16, 17: courtesy Trevor Paglen and Bellwether Gallery, New York; p. 20: © 2008 Artists Rights Society (ARS), New York /ADAGP, Paris © Sophie Calle, courtesy Galerie Perrotin; p. 21: © 2008 Artists Rights Society (ARS), New York/ ADAGP, Paris © Sophie Calle, courtesy Electronic Arts Intermix (EAI) New York; p. 22: courtesy Guthrie Lonergan; pp. 24, 25, 26, 27: courtesy Mohamed Camara and Galerie Pierre Brullé; p. 28 (above): courtesy Miranda July, Harrell Fletcher and Mary Mcafee; p. 28 (below): courtesy Miranda July, Harrell Fletcher and Serafina Grace; p. 29 (above): courtesy Miranda July, Harrell Fletcher, and Genevieve Sage.; p. 29 (below): courtesy Miranda July, Harrell Fletcher and Guruamrit Khalsa; pp. 30, 31: courtesy Gallery Olaf Stueber; pp. 32, 33, 34, 35: courtesy Hasan Elahi; pp. 36, 37: courtesy Sharif Waked; pp. 38, 39: courtesy Yvon Lambert Gallery; pp. 40, 42: courtesy Thomson & Craighead; pp. 43, 44: courtesy Postmasters Gallery; pp. 45, 46: courtesy Eyebeam R&D Lab, Jonah Peretti, Michael Frumin, and Huffington Post; pp. 47, 48, 49: courtesy Kota Ezawa and Murray Guy, New York; p. 71: courtesy Yvon Lambert Gallery

Boards of Trustees